# ANCIENT BRONZES
## FROM LURISTAN

לכבוד ר' ... ג'/3

ה"... מינר...

Danil Wasserstein

London 1985

# ANCIENT BRONZES
# FROM LURISTAN

P. R. S. MOOREY

PUBLISHED FOR
THE TRUSTEES OF THE BRITISH MUSEUM
BY
BRITISH MUSEUM PUBLICATIONS LIMITED

ISBN 0 7141 1076 0 Cased
0 7141 1089 2 Paper

*Published by the British Museum Publications Ltd.,*
*6 Bedford Square, London WC1B 3RA*

*Printed in Great Britain*
*at the University Press, Oxford*
*by Vivian Ridler*
*Printer to the University*

# CONTENTS

# FOREWORD

THE earliest example of the class of objects known to collectors and archaeologists today as 'Luristan Bronzes' (from Luristan in Western Iran) is a 'finial' (BM 87216) which reached the British Museum in 1854, but this was an isolated object.

About forty-five years ago, it is said, the peasants of somewhat remote Luristan made the earliest massive discoveries of the ancient cemeteries containing large quantities of bronze and sometimes iron objects. At first they melted the bronzes down; the iron was thought too corroded for any use and so they threw it away. But soon they were induced by dealers, instead of melting or discarding their finds, to trade them to collectors and museums, and the often unfamiliar, bizarre, and vigorous shapes of the Luristan bronzes captured the taste and interest of the public. This was especially so after the impressive international exhibitions and congresses of Iranian art held in Philadelphia (1926), London (at the British Academy in 1931), and Leningrad (1935), and illustrated by the splendid *Survey of Persian Art* (14 vols. 1938–60) edited by the organizers of the exhibitions, the late Professor Arthur Upham Pope and Dr. Phyllis Ackerman. Yet it is only in the last three years that any real archaeological information about the circumstances and date of these cemeteries and their contents has been made public, thanks particularly to the work of Professor Louis Vanden Berghe, of the University of Ghent. But since still today no special study of this most interesting phase of Near-Eastern art exists, it was decided to invite Dr. P. R. S. Moorey, Senior Assistant Keeper in the Ashmolean Museum, Oxford, who has made a special study of this subject, to write this booklet for the guidance of the general public.

R. D. BARNETT
*Keeper of Western Asiatic Antiquities*

*January 1973*

# PREFACE

WITHIN a few years of their first discovery in quantity many of the bronzes which form the subject of this essay became collectors' pieces, greatly admired for their fine craftsmanship and exotic decoration. Increasing demand from western museums and collectors has steadily stimulated the local Lur tribesmen to exploit ever more intensively the unexpected source of wealth which lay so easily to hand. First by chance, then through systematic search, cemetery after cemetery was ransacked for its bronze furnishings, which were widely distributed without any but the vaguest record of their source and archaeological context. Indeed, the phrase 'Luristan Bronze' was so valuable commercially that it was often unscrupulously used to describe bronze objects which had little or no real connection with this Persian province.

Any attempt to redress the balance by classifying the bronzes by type, setting them in their chronological range and reconstructing the society which made and used them is fraught with all the problems and uncertainties of a salvage operation. In the last ten years intensified fieldwork in Luristan and other parts of Persia, metallurgical research in laboratories and systematic study of the bronzes in public and private collections has brought some order into the very heterogeneous collection of objects described for the last forty years as 'Luristan Bronzes', but there is still much which is matter for debate. The essay which follows is an attempt to present current knowledge as concisely as possible with particular reference to the very representative collection of bronzes from Luristan now in the British Museum. Books listed in a short bibliography will enable the reader to follow up lines of inquiry only briefly explored here.

## ACKNOWLEDGEMENTS

The photographs were taken by the British Museum Photographic Service, and the maps were drawn by Mrs. Pat Clarke; thanks are also due to Mrs. C. Mendleson for assistance with the short check-list on pp. 45 ff.

# LIST OF ILLUSTRATIONS

IX. Bronze finial in the form of a rampant ibex with a lion's head and neck on each shoulder. (BM 123541; L. 18·1 cm.)

Xa. Bronze finial in the shape of a 'master-of-animals' with two faces and flanking cocks' heads. (BM 108816; Ht. 17·8 cm.)

Xb. Bronze finial in the shape of a 'master-of-animals' with a single face. (BM 115514; Ht. 13 cm.).

XIa. Bronze finial in the shape of rampant lions with lions on their backs mounted on a bottle-shaped support. (BM 122929; Ht. 27·7 cm.)

XIb. Bronze finial in the shape of rampant wild goats. (BM 122911; Ht. 8·9 cm.)

XIIa. Anthropomorphic bronze tube. (BM 132346; Ht. 16 cm.)

XIIb. Anthropomorphic bronze tube. (BM 130685; Ht. 13·6 cm.)

XIIc. Anthropomorphic tube with faces at one end only. (BM 123300; Ht. 9·6 cm.)

XIIIa. Base silver pin-head in the form of a 'master-of-animals' on an iron shank. (BM 132927; L. 22·5 cm.)

XIIIb. Base silver pin-head in the form of a 'master-of-animals' in a circular frame. (BM 123299; L. 8·5 cm.).

XIIIc. Bronze pin-head in the shape of a stylized lion-head, originally on an iron pin. (BM 128783; Ht. 5·1 cm.)

XIVa. Pin-head in the shape of a winged monster. (BM 128607; W. 7 cm.)

XIVb. Broken bronze pin-head in the shape of stylized 'trees' framing rampant goats. (BM 128780; Ht. 8·2 cm.)

XVa. Bronze disc-shaped pin-head decorated with a female figure. (BM 132900; L. 24 cm.)

XVb. Bronze disc-shaped pin-head decorated with a floral frieze. (BM 132025; L. 41·6 cm.

XVI. Decorated bronze goblet. (BM 134685; Ht. 19 cm.)

XVII. Decorated bronze situla with lid. (BM 130905; Ht. 14·8 cm.)

XVIII. Decorated cast-bronze vessel. (BM 130679; L. 14 cm.)

XIX. Bronze spouted vessels. (BM 128600; Ht. 14·6 cm. BM 128601; Ht. 11·5 cm.)

XX. Decorated spouted vessel. (BM 132930; Ht. 8·9 cm.)

# CONCISE TECHNICAL GLOSSARY

THE following terms are commonly used in studies of ancient Persian metalwork:

ANNEALING: the process of heating to a red heat and then cooling to remedy the brittleness of copper and bronze when hammered too much; the metal returns to a soft, workable condition.

BRAZING (hard soldering): the joining of metal surfaces by running a fusible metal solder, with a lower melting-point than the metal to be soldered, between them. Carried out at, or above, red heat.

CASTING: making artefacts by running molten metal into a mould, in antiquity usually of baked clay or stone, cut as a negative of the object desired.

CHASING: hammering the metal down from the front to produce a low relief design with linear margins.

ENGRAVING: linear designs made with a sharp tool which removes the metal from the groove it cuts. A method unlikely to have been used before the manufacture of iron tools (see also TRACING).

LOST-WAX CASTING (the *cire-perdue* method): a model of the object to be cast is made in wax, sometimes over a clay core, and then covered with layers of clay. This is baked to harden the clay and melt out the wax. Molten metal is poured into the cavity left by the wax and allowed to cool; the clay mould is then broken away and the metal object finished with a chisel.

RAISING: making a sheet-metal vessel by hammering from the outside. A disc of metal is worked over a special anvil (*stake*) with unusually long arms which can enter the vessel being made.

REPOUSSÉ: hammering a design up from the back of a piece of sheet metal so that it appears in relief on the front.

SINKING (or hollowing): making a sheet-metal vessel by hammering the metal down into a suitably shaped depression cut into a block of wood.

TRACING: linear designs made with a slightly blunt chisel which displaces and compresses, but does not remove, the metal from the groove it makes (see also ENGRAVING).

WELDING: heating the two pieces of metal to be joined to near their melting point and then hammering them together. Used to join pieces of iron; could not have been used in antiquity to join copper or bronze.

For further technical details see:

H. H. COGHLAN, *Notes on the Prehistoric Metallurgy of Copper and Bronze in the Old World*, Oxford, 1951.

H. MARYON, 'Metalworking in the Ancient World', *American Journal of Archaeology*, liii, 1949, pp. 93–125.

H. E. WULFF, *The Traditional Crafts of Persia*, Cambridge, Mass., 1967.

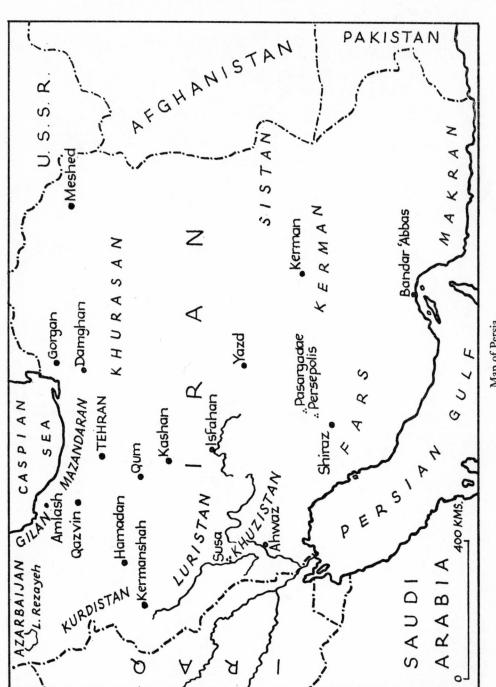

Map of Persia

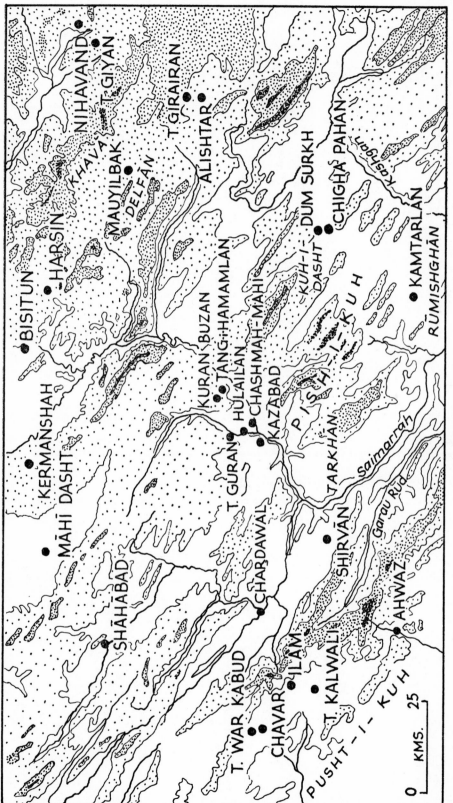

Map of Luristan

# INTRODUCTION

THE Persian province of Luristan, occupying a central position on the country's western frontier, is a region of open plains intersected by the high, treeless ranges of the Zagros mountains. It is separated from Iraq by the formidable barrier of the Kebīr Kūh which forces those who seek to enter Luristan from the west to come upstream from the south-east, or downstream from the north-west. The natural routes of entry from Iraq to the highland basins of Persia skirt its northern and southern fringes. Within the province the warm, low-lying pastures of the west (*Garmsīr*) are separated from the cooler, higher plains of the east (*Sardsīr*), by the Kūh-i-Sefīd, which offers passage through its central ranges for seasonally migrating tribes. The plains, watered by the Saimarrah and Kashgan rivers and their tributaries, have long supported a hardy, independent people relying on simple agriculture and husbandry, primarily horse breeding, for their livelihood. The region is a natural fortress: an ideal refuge for recalcitrant and turbulent tribesmen. In antiquity the rich cities of the Mesopotamian plain to the west were persistently raided and plundered by these marauding highlanders, sometimes acting independently, at others in the employ of Mesopotamian or Elamite kings.

Although bronze objects typical of the exotic style now associated with Luristan first reached museums in Western Europe in the middle of the last century (Plates X*a*, *b*) with the earliest collections of antiquities from the Near East, their real origin long remained a puzzle. They were then usually attributed to Cappadocia or Armenia. The extensive and systematic robbery of the cemeteries of Luristan by local tribesmen, suddenly made aware of their commercial potential, must have begun sometime in the nineteen-twenties for, by 1929, when Ernst Herzfeld first drew attention to the new Persian discoveries and definitely identified the source of the bronzes, major collections had already been formed by dealers in Paris and New York.

Virtually all the bronzes came without certain provenance from plundered cemeteries of stone-built cist or gallery graves varying considerably in date, but predominantly of the earlier first millennium B.C. Exceptionally, as at Dum Surkh and Tang-i-Hamamlan, bronzes were anciently deposited in shrines, again in quantity. Any attempt at precision in defining the main areas from which the distinctive Luristan bronzes have been plundered in the past forty years is for the moment impossible and,

as so much has already been stolen, likely to remain one of the most obscure aspects of the whole subject. The primary source may provisionally be defined as an area running from the region of Ilam in the west to Nihavand in the east. It is more difficult to be precise about limits to north and south. There is little evidence so far for major finds south of the Kashgan river; the northern limit seems to be in the region of the modern Baghdad–Hamadan road, with exceptional finds reported from further north.

Recent excavations on settlement sites in the Hulailan plain and cemeteries around Ilam, as well as earlier excavations at Kamtarlan and Chigha Sabz, Tepe Giyan, and Tepe Djamshidi, indicate, as is only to be expected, the existence of a local metal industry throughout Luristan from at least the later fourth millennium B.C. So long as a relatively restricted production of simple personal ornaments, tools, weapons, and sheet-metal vessels, normally undecorated, was the total extent of this industry, Luristan was no different from many areas of the Near East in antiquity within reasonable reach of the necessary raw materials. It is the comparatively sudden appearance of an immensely varied and richly decorated range of cast bronzework, including certain types of object unknown elsewhere, which sets Luristan apart. Excavations in the shrine at Dum Surkh, important single finds at Baba Jan in eastern and at Chinan in western Luristan, and comparative evidence from outside Persia indicate that the greatest prosperity of Luristan's bronze industry may be dated from the ninth to the seventh centuries B.C. It is contemporary with the earliest production of iron objects in the region. So far controlled excavations have only revealed contemporary cemeteries, like those in the region of Ilam explored by Vanden Berghe, which generally lack elaborately decorated bronzes, though graves are often well equipped with metal weapons, personal ornaments, and utensils, normally plain.

The bronzes most characteristic of this phase in Luristan's metal industry are characterized by a particularly rich and often highly stylized form of cast-bronze decoration in which animals play the main part, but strange creatures, in which the natural features of man and beast are often inextricably mixed, have an important subsidiary role. Its most notable products are the decorated whetstone handles (Chapter I), various pieces of horse-harness (Chapter II), certain ritual objects (Chapter III), and some very elaborate pins (Chapter IV). It will become clear that, despite an immense variety of detail arising generally from the fact that each casting by the lost-wax process is unique, there is an essential homogeneity in all the decoration. Technically distinct from these cast-bronze objects, but linked to them in many ways by style and iconography are a

18

range of sheet-metal objects (Chapters V–VI), considerably more widely distributed in west Persia than the typical cast bronzes of Luristan.

The rather sudden, and very remarkable, change in the character of Luristan's industry has generally been attributed to invaders from outside the region. As, in the absence of written records, they cannot certainly be named, they have been variously identified. It was first suggested that the change was stimulated by Kassites driven into the Zagros mountains in the twelfth century B.C. after the collapse of the Kassite political supremacy in Iraq. There are a number of objections to this theory. The material cultures of Iraq and Luristan in the relevant periods have little in common. Although a people known to the Assyrians and later Greek geographers as 'Kassites' were probably to be found in some part of Luristan it may not be assumed, in the absence of other evidence to link them, that they had any direct connection with the earlier rulers of Iraq. There is no evidence that the Kassites were persecuted or systematically expelled from Iraq. Indeed it seems, to judge from the occurrence of Kassite personal names, that they remained a distinct, if increasingly less influential, element in the population well into the first millennium.

A more popular theory has seen the sudden expansion of Luristan's industry as the direct result of nomadic intrusions into the province from the north as part of the very complex series of migrations which followed the entry of the Iranians into western Persia after *c.* 1200 B.C. Here again archaeological evidence as yet lends little support. The very fact that this industry did not develop further north, closer to mines west of the Caspian, suggests that its distinctive character owed little or nothing to intrusive Iranians, who had a bronze industry of their own, perhaps in part represented by the so-called 'Amlash Bronzes'. None of the pottery most closely associated with the Iranians in the earlier stages of their penetration has yet been found in Luristan. Even less convincing is the identification of the creators of this industry with the Cimmerians. There is no evidence that the Cimmerians, best known for their activities in Armenia and eastern Turkey in the later eighth and early seventh centuries B.C., ever penetrated into Luristan as a recognizable group. If they reached so far south then it was in close association with the other Iranian peoples from whom, archaeologically at least, they are indistinguishable and not until the Luristan bronze industry was already in decline.

In seeking an explanation for the marked change in Luristan's bronze production, three of its characteristics are particularly relevant: the presence of objects unknown outside the region, the strong influence of Babylonian and Elamite imagery in the decorated bronzes and the wide range of the local smith's repertoire.

If its creators were Kassites, Iranians, or Cimmerians, it is strange that none of the most distinctive cast-bronze objects have yet been found, nor even their prototypes identified, outside the central Zagros. It has been authoritatively argued that the prevalence of horse-trappings and portable objects indicates a people wholly nomadic. It seems unlikely, however, that a people with such a way of life would require, let alone support for some considerable period of time, a production of bronzework so varied as that of Luristan, not to mention pioneering the general production of iron tools and weapons. That some of the industry's patrons led a nomadic existence is virtually certain, since seasonal transhumance has long been a familiar pattern of life among the region's pastoralists; that they all did seems unlikely. If the occupants of the contemporary cemetery 'B' at Tepe Sialk may be taken as a guide, then the owners of the fine bronzework from Luristan were members of a warrior aristocracy, distinguished, as so often in history, by the possession of a horse and the means to equip it and themselves for hunting or war. They were the leading members of the larger, permanent settlements in the western plains or the smaller citadels or manors in the higher eastern plains dependent on agriculture, horse-breeding, and perhaps control of the north–south trade route, for their prosperity. In the present state of knowledge it is best to respect their anonymity.

Why and how, it may now be asked, did these people come to enjoy such prosperity in the earlier first millennium B.C. that they could support an industry so much more elaborate than that which had served their predecessors?

So long as Luristan was overshadowed politically and economically by Elam, an ancient urban civilization in the plains of Khuzistan with an outstandingly vigorous and enterprising metal industry of its own, there was no opportunity for such a development. Political changes towards the end of the second millennium B.C. radically altered the situation. Nebuchadnezzar I, King of Babylonia (1124–1103 B.C.) crippled the political power of Elam, whilst his successors for the next century or more continued its subjection and interfered in its dependencies to the north. For about three centuries thereafter Elam disappears from Mesopotamian records and there are no local texts. The most tangible evidence from Luristan for an increased Babylonian presence is a series of weapons inscribed in cuneiform with the names of various Babylonian kings, and their officers, from the early twelfth to the mid-tenth century B.C. (Plate IIa, b).

No longer in competition with Elam's metal industry, perhaps even reinforced by refugee Elamite smiths, the bronze workers of Luristan were

free to develop a style congenial to their local patrons, now reasserting themselves in the political vacuum left by the eclipse of Elam. Babylonian political influence, which seems to fade after the middle of the tenth century anyway, was never as strong as that of Elam.

The decline of the Luristan metal industry, some time in the later seventh century B.C., was probably due to the increasing political unity of the Medes and Persians. By cutting off the lines of supply from mines to the north and east and by supporting smiths of their own, they slowly strangled Luristan's industry. At the same time the aristocracy of Luristan, patrons of its industry, suffered economically far more at this time from these intrusive Iranian tribes that they ever had from the more sporadic attacks of the Babylonians and Assyrians, whose penetration into their mountain strongholds was never very damaging. The well-known dependence of the early Achaemenian kings on foreign artisans, including metalworkers, in the later sixth century B.C. may indicate that the workshops of western Persia had suffered a setback so severe that they had never recovered.

# I. WEAPONS AND TOOLS

BRONZE weapons are the commonest component of all collections of Luristan bronzes, but tools which might be used by the smith, carpenter, or farmer are very rare. The circumstances of their discovery explain this discrepancy. In the cemeteries from which the bronzes were plundered even the poorest male graves appear to have contained a few simple weapons; the richest were amply stocked with them. Workmen's tools are normally found, not in graves, but on settlement sites or in scrap hoards, and then not commonly in the Near East. The only tool generally reported from Luristan is a *fork* with short socket and two long prongs, almost certainly used as a spit for cooking meat set on the prongs. Such objects were found in cemetery 'B' at Tepe Sialk, east of Luristan, associated with sheet-metal cauldrons.

Many of the axe-blades from Luristan have never been ground down for use and many of the axe-heads, particularly those with spiked butts, have the blade set at such an angle that it would have been useless for all practical purposes. It must be assumed that such weapons were made specially for deposit in graves or shrines as votives; those with inscriptions in some cases attest this. The elaborately decorated axes no doubt had a symbolic significance for their creators which now eludes us. It is possible that some, if not all, of the most elaborately decorated iron swords represented a deity, as seems to have been the case with similar objects among the Hurrians and Hittites.

It is the *shaft-hole axes*, *adzes*, and *pick-axes*, and to a lesser extent the *daggers* and *swords*, reported without context from Luristan, which provide a very important, if skeletal, guide to the history and affiliations of Luristan's bronze industry from *c.* 2500 B.C.—the date of the earliest plundered cemeteries—to the tenth century B.C. They alone may be securely dated by comparison with similar weapons from controlled excavations elsewhere in the Near East. This in itself is significant for it shows, in contrast with the earlier first millennium B.C., that Luristan's bronzeworkers shared a common repertory at this time with their colleagues in the long-established urban civilizations to the south and west. Indeed there are many tools and weapons reported from Luristan which might well have been made during this time in Elam, Mesopotamia, or possibly even North Syria. This could reflect the activities of smiths serving the Hurrian-speaking peoples who spread westwards across much

of the Near East from the later third millennium B.C. Trade in copper and tin from Persia, along a northern route into Assyria and Syria, may also have encouraged contacts between smiths in the regions through which it passed.

Yet despite this striking parity of forms over a wide area, the earliest signs of divergent metalworking traditions in Luristan are already apparent and may be ascribed primarily to Elamite influence. Cast or traced zoomorphic ornament on tools and weapons, so characteristic of Luristan, is rare elsewhere, save in Elam. Here, by at least the late third millennium B.C., it was customary to decorate metal objects, often for parade or votive use, in this way. Some adzes, a few axes and a series of cudgel-heads or maces with crudely cast animals or human figures in relief on the surface from Luristan illustrate the diffusion of this fashion northwards in the earlier second millennium B.C. The two classes of decorated axe most distinctive of Luristan's industry at its most prolific in the earlier first millennium B.C. were immediately inspired by Elam, though the ultimate origin may be Mesopotamian or Syrian.

The various *spike-butted axes* include examples, almost certainly among the earliest, inscribed for King Shilhak-Inshushinak of Elam (later twelfth century) and King Nebuchadnezzar I of Babylonia (1124–1103 B.C.). But neither bears the elaborate plastic ornament these axes were to develop in the subsequent three centuries in Luristan. Spikes were then tipped with bird, animal, or human heads, or cast entirely as wild boars or hounds; blades sprang from a lion's jaw (Plate I*a*); more rarely there was relief decoration on the blade. Bronze adzes and pick-axes with spiked-butts and zoomorphic decoration, some with iron blades, were also made at this time. Characteristic as this class of axe is, it does not illustrate the distinctive decorative style and technical ingenuity of its makers as well as a series of *crescentic axes* (Plate I*b*). These, made from *c.* 1100 to 750 B.C., have a bronze lion-mask at the junction of blade and shaft-hole, often of iron, and a lion couchant cast on the butt.

Until the later second millennium B.C. the *daggers* used in Luristan consisted of simple, tanged copper or bronze blades riveted to a handle which was normally of some organic material, and has consequently perished, or very occasionally of metal, when it has survived. In about the fourteenth century B.C. Luristan adopted from the west a type of dagger in which hilt and blade were cast as one, with the hilt flanged to take inlaid plaques of wood, bone, or metal. The bone inlays were often cut so as to give the hilt a winged or 'ear' pommel. These inlaid hilts were often exactly copied entirely in bronze with the hilt sometimes made separately from the blade and subsequently cast on to it. It is not

customary for these weapons to be elaborately decorated like the axes, but some have inscriptions and designs traced on the hilt or upper blade. From the tenth century B.C. bronze hilts were cast on to iron blades and increasingly the standard shapes of bronze daggers were faithfully copied in iron. A magnificent silver hilt (the so-called Lawrence Hilt), originally cast on to an iron blade (Plate III), has a winged pommel and richly traced decoration comparable to that found on decorated sheet-bronze objects from Luristan, c. 750–650 B.C.

None of the bronze weapons are long enough to be called swords (i.e. over about 20 inches in length), but there is a very remarkable series of decorated *iron swords* from Luristan made sometime during the ninth to eighth centuries B.C. in a closely associated group of workshops. Both in form and technique they derive directly from bronze prototypes and illustrate in detail the genesis of a new technology for a metal much less tractable than copper or bronze (Plate IIc).

Considerably more evidence is required from controlled excavations before it will be possible to establish a detailed chronology for the thousands of undecorated bronze *spearheads* and *arrowheads* reported from Luristan. The spearheads are more often socketed than tanged; the arrowheads were invariably tanged until the introduction, in the later eighth century B.C., of the socketed, trilobe arrowhead.

Various bronze *maceheads* and *cudgels*, apart from the elaborate votive objects already mentioned, have close parallels in Elam and Mesopotamia, only rarely bearing the decoration typical of Luristan in the earlier first millennium B.C. Examples of all phases in the weapons' history from the middle of the third millennium to the seventh century B.C. occur in Luristan.

Bronze requires more whetting than iron and the *hone* was always of major importance in antiquity. Normally they were tools of the utmost simplicity. The stone might be cut in a variety of ways, but it was generally just perforated at the top and fitted with a simple metal ring, for suspension from a belt. In Luristan, from the eleventh to eighth centuries B.C., as nowhere else in the Near East, hones had richly decorated bronze handles. Handles with similar zoomorphic decoration are known from at least the twelfth century onwards in Elam, again no doubt the source of inspiration for Luristan, and Babylonia.

Animals, real and imaginary, particularly various *capridae*, and semi-human creatures alone or in combination, make these handles a microcosm of the Luristan smiths' repertory of motifs (Plate IV).

24

# II. HORSE-HARNESS

THE earliest history of the domesticated horse in Persia is still obscure, though it may well have been used there before its first appearance in Iraq and Turkey late in the third millennium B.C. Although horses were ridden at this time, they were much more commonly used, particularly after *c.* 1600 B.C., to draw light chariots in war, hunting, and racing. The animal was normally ridden bare-back, controlled only by a whip and simple cords passed round the neck; but in a war-chariot where speed, control, and manœuvrability were so important, more elaborate harnessing with metal-bits was indispensable. The earliest known bronze horse-bits from the Near East date to the late fifteenth or early fourteenth century B.C. At this time the Hurrians, under their Mitannian overlords, were the masters of horse-training and they may well have invented it. As costly objects, primarily for military use, they never completely superseded bits of rope with horn, antler, bone, or wooden cheek-pieces, which remained the commonest type of horse-harness.

It is possible that bronze horse-bits of this period have been reported from Luristan (Plate V*a*), but generally speaking the metal horse-trappings from this region date to the earlier first millennium B.C. At this time, as Assyrian palace reliefs make clear, cavalry was rapidly replacing chariotry as the main mobile force in most Near Eastern armies. Throughout the Late Assyrian period (*c.* 1000–612 B.C.) horses for the Assyrian armies came to the administrative centres of their Empire through trade, or as spoil or tribute, from the plains of western Persia where they bred so well. It is not surprising then that the bronzeworkers of Luristan should have exercised their skill in decorating horse-trappings in a way unparalleled elsewhere at the time. The horse-bits from Luristan share a common ancestry with those from countries to the west, differing only in their rich decoration and in a preponderance of rigid over jointed mouthpieces. In graves they were often placed under the dead person's head, but they should not for this reason, following modern Lur phraseology, be known as 'head-rests'. There is more evidence than is sometimes allowed, in signs of wear on the bits themselves, that many of the richly decorated bits were actually used, if only as parade harness, and were not just votives specially made for the grave.

Virtually all the cheek-pieces are provided with two loops for the cheek-straps of the headstall and central hole through which pass the

ends of the mouth-piece, terminating in a third ring or loop for the reins. Spikes were often placed on the inside of the decorated cheek-pieces to reinforce their action against a horse's jaw. Five main types of horse-bit, classified by Dr. Potratz on the shape of their cheek-pieces, have commonly been reported from Luristan:

I. *Openwork, rectangular cheek-pieces*, sometimes with an animal's head at the front end of the upper edge, suggesting that the rest of the cheek-piece was conceived as a very stylized rendering of the recumbent animal's body (Plate VI*a*). Such bits, undecorated, were in use in Assyria in the ninth century B.C., but had passed out of fashion by the later eighth century B.C. Those from Luristan, where an example was excavated at Tang-i-Hamamlan, are contemporary.

II. *Circular cheek-pieces* appear on the earliest horse-bits from the Near East, but were not in use after the late second millennium B.C. Whether or not such cheek-pieces were used later in Luristan is still uncertain; it is certain that the wheel-shaped objects sometimes said to be cheek-pieces are in fact harness-rings (pp. 27 ff.).

III. *Bar-shaped cheek-pieces*, most commonly on a jointed mouth-piece in contrast to the other groups where the rigid mouth-piece is normal. Similar bits were found in the graves of cemetery 'B' at Tepe Sialk, indicating that they were probably in use in Luristan from at least the ninth to seventh centuries B.C. Close copies in iron are also known in both regions, but only in Luristan are the ends of the bronze cheek-pieces sometimes cast as animal-heads (Plate V*b*).

IV. *Cheek-pieces shaped as a* V, each end terminating in the head of an animal or bird, usually a cock. Such cheek-pieces do not appear on Assyrian reliefs, but two remarkably similar ones were found in Greece at Delphi. They are not likely to have reached that site before *c.* 700 B.C. In Luristan, on the evidence of their decoration, these bits may be dated *c.* 850–650 B.C.

V. *Cheek-pieces in the form of flat plaques cast as animals*, real or imaginary, or combinations of men and monsters (Plates VI–VII). These are very characteristic of Luristan and reported from the region in great variety. They present every aspect of the iconographical repertoire of the Luristan smiths, as well as certain motifs otherwise unrepresented among the bronzes from the region. Cheek-pieces in the shape of a horse only appear on Assyrian reliefs in the reign of King Sennacherib (704–681 B.C.), and then only on the royal chariot horses or on the model of a horse's head at the end of the pole on his ceremonial wheeled chair. Such a cheek-piece, in bronze, was found at Nimrud in Assyria

and others, in Greek lands, on Samos and at Lindos on the island of Rhodes. It is most likely that the Assyrians adopted this type of decorated cheek-piece from western Persia, where it was in vogue from at least the early eighth to the mid-seventh centuries B.C. The mythological beasts, sphinx, chimaera, and griffin, and the 'master-of-animals' represented on these cheek-pieces may be exactly matched by designs on Elamite glazed bricks of the later eighth century B.C. Some of the animals, notably the common horse and moufflon, but also the rarer boar, bull, and lion, were local Luristan fauna; others which appear very rarely, like the stag and elk, indicate some more northerly influence. Skill of execution varies greatly. Closely observed and often beautifully modelled portraits of animals, sometimes winged, have ill-conceived and crudely executed counterparts. This almost certainly denotes workshops in different localities or variations in craftsmen's skill, rather than significant differences in time between objects of such similar use and basic form.

These metal horse-bits are only the most elaborate among a variety of metal horse-trappings used in Luristan from the ninth to later seventh centuries B.C. A large group of *wheel-shaped objects*, sometimes spoked, sometimes an open ring, probably served as ornaments for the horse's headstall (Plate VIII). The ferrule is decorated at the top with a moufflon, or more commonly just its head, flanked by predatory beasts, or a semi-human head similarly threatened. When not spoked the central aperture may occasionally frame a grotesque human figure wearing a horned crown. On most of these rings there is a single suspension loop behind the animal or human head at the top. More rarely there is also a subsidiary loop below the main ring. Twin rings, in the shape of a figure-of-eight laid on its side, have lateral suspension loops and may have acted as the junction for two straps rather than primarily as decoration.

In Luristan, as on Assyrian reliefs and on a cylinder seal from cemetery 'B' at Tepe Sialk, there is evidence that horse-collars were decorated with cut-out sheet-bronze fittings sewn on to a leather or fabric band. A popular shape was a two-armed 'cross of Lorraine' above a round disc; they were worn on the collar arranged in horizontal rows. Bells, sometimes shown on Luristan cheek-pieces of group V cast as horses, and various pendants, generally animals, were also fitted to the collar.

By the seventh century B.C., sheet-bronze *blinkers* and *forehead pieces*, some decorated with chased and repoussé designs, were in use in Luristan, perhaps under western influence, where they are represented as early as the reliefs of Ashurnasirpal II in the ninth century B.C.

At the time of the Luristan bronze industry's greatest prosperity neither the rigid saddle nor the stirrup was in use. There is, moreover,

no evidence at this early date for the modern buckle by which the harness could be quickly and easily adjusted in the field. Junctions were sewn down or knotted. There are very simple cast-bronze 'buckles', without a tongue, which may have been used to secure the saddlecloth or other harness, as well as the belts of human beings. These objects often have zoomorphic decoration. They are commonly, and almost certainly incorrectly, known as 'bow-rings'. They would have been little use in stringing or firing a composite bow.

# III. FINIALS AND DECORATED TUBES

THE most unusual objects among the whole range of cast bronzework reported from Luristan are the small pairs of rampant, confronted animals, either free-standing or flanking an anthropomorphic tube, variously called *standards*, *funeral statuettes*, or *talismans*. They are still without parallel beyond this region of Persia. Whatever role they played it was not as structural elements in a larger object; they and their mounts were self-sufficient. Their small size, rarely above seven inches high, precludes use as battle or processional standards, as known from Assyrian reliefs and rare finds, including some of the earlier second millennium B.C. from Luristan. The term *finial* is used to describe them here in order to avoid any implicit assumption about their function, which remains debatable.

There may be little doubt that these finials were mounted vertically on the top of the hollow, cast-bronze, bottle-shaped, or conical supports so often associated with them on the antiquities market (Plate XI*a*). A pin with long shank and decorated head was passed down the central aperture joining finial and mount, perhaps also fixing it to the ground. All the finials were made to appear the same whether seen from front or back and some of the mounts are decorated with human heads like those of the finials. Original mountings with the various components corroded together are very rare, though they were reported from the earliest clandestine excavations. Most complete mountings are modern reconstructions.

These objects, apparently found both in graves and shrines, are most likely to have been cult symbols, comparable to the icons of Christian Europe. It is possible that some of the heraldic groups of rampant animals shown on cylinder seals of the 'Mitannian Style' (*c.* 1500–1200 B.C.), closely resembling these finials in form, actually represented small cult objects; but until excavated examples of this period occur outside Persia this is mere speculation. It may not be entirely inappropriate to compare them with 'household gods', like the *teraphim* of the Old Testament, referred to in texts from Nuzi (Yorgan Tepe), in Iraq, *c.* 1500–1400 B.C. These were something more than religious symbols: tokens of a man's legal position within his family and society. If the Luristan finials are indeed comparable, this might explain their presence among grave furnishings.

Their date is almost as debatable as their function, since it still largely rests on iconographic and stylistic arguments, which offer an invaluable guide to the main period of production but do not permit close dating of individual examples. The earliest, probably the more naturalistic renderings of goats and lions, appear at the very end of the second millennium B.C. in the earliest phase of the local Iron Age. The latest were made in the later eighth or earlier seventh centuries B.C. Only in western Luristan have rare examples so far been found in graves discovered by scientifically controlled excavations. The basic form of the finials does not change, nor in any primary sense does the imagery. The variety of detail may be accounted for by the uniqueness of any object made, as were all these finials, by the lost-wax process. Close similarity in details of manufacture suggest a comparatively restricted group of workshops in which the most elaborate 'master-of-animals' finials are unlikely to have been made for more than a generation or two in the ninth or eighth centuries B.C.

These finials may be divided into two main structural groups: those cast in one with a central tube and those cast without, in which the only links between the two rampant animals are the horizontal rings at top and bottom between their feet (Plate XI*b*). In the latter case a tube of sheet metal was passed between the upper and lower rings to form the central boring. Two of the most prevalent themes in ancient Near Eastern Art occur persistently: animals rampant on either side of a tree and the 'master- or mistress-of-animals', commonly, but misleadingly, referred to as 'Gilgamesh' finials. The animals are almost always either goats or lions, which are rendered in the highly stylized Luristan manner with prominent eye-ridges. In the case of the goats it was probably a pin with floral head, perhaps even a real branch, which secured the mounting, in that of the lions, one with an animal or human head. From the lion finials developed the type of finial with an anthropomorphic tube cast in one with the flanking beasts. The only human features are one, or more, faces on the tube and sometimes arms and legs (Plate X). The figure is naked or wears just a girdle and cross-straps. It is often impossible to tell certainly whether male or female is intended. As with the free-standing goats and lions, wings, bird or animal heads, complete animals or symbols, may be added on the backs and haunches of the flanking animals.

Apart from these elaborate finials there are also a wide variety of simpler, *decorated bronze tubes* from Luristan (Plate XII). They are cast with a central boring and decoration in low relief on the surface. Though they do not have such varied silhouettes as the finials, their close relationship with them is clear. It may be seen in a marked similarity of form, a common range of decorative motifs and virtually identical stylistic

traits in the modelling. From the placing of their decoration it is clear that these tubes must generally have been mounted vertically; in most cases no doubt exactly like the finials. Three main groups may be distinguished on the basis of the primary motifs in their decoration: those cast as a human figure with emphasis on the sexual organs; those in which the head alone represents the only human, or, more exactly, sub-human element; and a number with animal decoration, usually feline.

Throughout the ancient Near East the nude female figure was widely used in the minor arts, particularly in the earlier first millennium B.C., both for decoration and more explicitly on votive objects. Luristan is distinctive not in its use of this theme, but in substituting bronze for the more common baked clay, ivory or bone, in blending male and female characteristics in a single figure, and in adding animal or birds' heads, generally cocks, to the main figure at shoulder level. This imagery at its most exotic is very well illustrated by a tube in the British Museum (Plate XIIa), which even has secondary heads. In Elam and Mesopotamia the nude female, whether goddess or votary, was often represented standing on a low podium, as were all these Luristan figures when set on their mounts.

The tubes on which the main decoration is a grotesque 'Janus-head' at one end bear a close formal relationship to the figure framed between threatening animal heads on the 'master-of-animals' finials. There are indeed a few tubes in which the head is similarly framed. More normally it stands alone and the highly stylized lion's head so typical of Luristan, with prominent sinuous eye-ridges, appears alone on the third group of tubes, either in profile or full-face, at one or both ends of the tube.

In the absence of local written records it is impossible to interpret the contemporary meaning of these extraordinary objects. Many valiant attempts have been made, but their very variety casts grave doubts on their validity. Even if it were certainly known whether the ultimate inspiration was Elamite, Mesopotamian, or Iranian the problem would not be much simpler. Ancient religious concepts were remarkably fluid: a single deity might have numerous attributes and an equal variety of roles, some of them, to modern minds, mutually exclusive. Moreover, religious motifs undergo subtle and complex changes of meaning as they migrate. The ancient Near Eastern 'master-of-animals', for instance, was to become 'Daniel in the Lions' Den' in the art of Romanesque Europe.

# IV. PINS, PERSONAL ORNAMENTS, AND TOILET ARTICLES

THE bronze *pins* found in Luristan surpass even the weapons in quantity, variety of form, and decoration, and in range of date. Although elaborately decorated bronze pins were made elsewhere in the Near East from the later fourth millennium onwards, they are comparatively rare. Nowhere, at any time, are they as numerous or as various as in Luristan during the earlier first millennium B.C. They were not only used in fastening garments and in dressing the hair, but also to secure the finials to their mounts and, when the head was richly decorated, as icons in their own right. Many pins were found in the shrine at Dum Surkh, where the more elaborate ones had served as votive gifts inserted in the walls. The simpler pins, as in Greek sanctuaries, may have been dedicated with clothes, for Elam and its northern dependencies were famous for their textiles.

Bronze pins, sometimes with pierced shanks, their heads cast as domes, cones, or spheres, their shanks decorated with mouldings or simple, traced linear patterns, have a long history in Luristan beginning in the third millennium and persisting into the seventh century B.C. when *fibulae* (safety-pins) gradually superseded them as garment fasteners. Pins with their heads cast in the shape of flowers or fruit, primarily the poppy or pomegranate—sometimes a cage representing the seed cases slit to remove the seeds or fruit—do not appear until the late second millennium B.C., becoming especially popular in the ninth to seventh centuries B.C. It was at this time that the Luristan smith produced an even richer variety of pin-heads inspired by local fauna: ducks, cocks, wild goats, moufflon, horses, frogs, and lions, shown either complete in the stylized manner of Luristan or as a flat lion-mask with curvilinear features (Plate XIIIc). A few of these pins have remarkable zoomorphic junctures: for instance the forefeet of a lion may be fused to become a wild-goat's head which the lion appears to threaten. Imaginary monsters were no less popular. Of particular interest is a creature, of Elamite origin, with the head and neck of a goat, the body and tail of a lion, and curved wings (Plate XIVa).

Peculiar to Luristan are the pins with large openwork heads set on a bronze or iron shank. The smallest of these pins may have been

functional, but the larger heavy ones are votives, differing from the finials only in form. Whether free-standing or framed the designs are strongly reminiscent of those used on the finials. Once again it is essentially a matter of constant variation on a single theme: a heraldic group of animals flanking a central device, usually a human or sub-human creature, more rarely a tree (Plate XIV*b*). When the frame is crescentic each arm terminates in an animal-head threatening the central figure. Sometimes the 'master-of-animals' has the body of a man with the head, or heads, of a lion, ibex, or moufflon, reminiscent of the 'nature-demons' who appear on prehistoric stamp-seals from western Persia and on certain Elamite monuments of the later second millennium B.C.

Another type of pin from Luristan, though it may have a northern origin, is again virtually unknown outside the region. In this case the top of the shank is hammered out to form a flat disk which bears chased and repoussé designs. In the shrine at Dum Surkh the earliest of such pins appear in the level dated to the eighth century B.C. Yet again such pins were both functional and votive. There are two main types:

I. The head of the pin is treated as an open field and a simple, often crudely executed, design is not necessarily dependent on a central point. Human figures and animals do not appear and most of the designs consist of geometric motifs, perhaps symbolic, and floral friezes (Plate XV*b*). Pins of this type were reported from the earliest clandestine excavations in Luristan and probably came from graves.

II. In this case the designs are composed of elaborate floral, animal, and human motifs, normally arranged round a central boss, often modelled as a female face, more rarely as a lion's head. These pins are very elaborately decorated, but very uneven in the quality of execution. They have been particularly associated with the Dum Surkh shrine and may primarily have served as icons. Their relation with the richly decorated cast-bronze pins, also found at Dum Surkh, may be closer than appearances suggest. They share the same iconographical range, allowing that it is possible to design elaborate compositions for chasing on sheet metal which would not be feasible for modelling in wax for casting. Well-established fertility symbols like the pomegranate, the rosette, the snake, and the goat suggest that these pins were dedicated to a fertility goddess, who may well be the woman in many cases represented on the central boss (Plate XV*a*). On some of these pin-heads, as on certain decorated tubes, the male partner has a more explicit role than is usual elsewhere in ancient Near Eastern art. A series of *sheet-metal pendants*, decorated like these pin-heads, are also reported from Luristan.

The sheet-metal *bracelets* from Luristan, decorated with simple chased or traced geometric designs, differ little from those in use over a wide area of Western Persia in the later second and earlier first millennium B.C., but the decorated cast-bronze bracelets are more individual. One type, produced in the eighth to seventh centuries B.C., is very distinctive. The hoop is a heavy bronze casting made in two parts secured together with short pins passed through socket-and-tenon joints. The upper surface is decorated with animals, lion-masks, and sub-human creatures in low relief. Similar bracelets were also made in iron.

Commonest of all cast bracelets are those with plain, narrow hoops and terminals modelled either as animals, often just the heads, or birds. These are the provincial variants of a fashion common to Assyria, Urartu, and north-west Persia in the earlier first millennium B.C. Indeed, it is only when stylistic traits distinctive of Luristan appear that it is possible to identify certainly the work of local smiths. Under the later Achaemenian kings court jewellers were to produce magnificent bracelets of gold and silver with animal terminals, like those of the Oxus Treasure in the British Museum.

A number of personal ornaments among the bronzes from Luristan were common products throughout western Persia in the earlier first millennium. At Persepolis on the great Achaemenian reliefs both Medes and Persians may be seen wearing a twisted or plain torc, bracelets, and ear-rings. Both *torcs* and *ear-rings* in bronze were made in Luristan to simple standard designs for centuries. The same is also true of anklets, worn by both men and women, probably in pairs. These are open-ended, sometimes with simple linear patterns traced on the terminals. The very heavy plain objects of this shape may in fact be ingots or currency rather than personal ornaments.

Many bronze *finger-rings*, cast or sheet metal, have variously shaped bezels cut with designs which reflect the motifs cut on contemporary seals more often than they do the exotic imagery of Luristan's smiths. Simple bronze *stamp-seals*, with negative geometric designs on the base, have handles on the back terminating in bird or animal heads, normally with a loop or hole for suspension. The decoration is sometimes in the style characteristic of Luristan from the ninth to seventh centuries B.C. A whole range of bronze *amulets* shaped as animals, human figures, boots, model vessels, or fruit were probably charms worn from the belt (as in north-west Persia) or on necklaces.

Most of the *mirrors* from Luristan, like those from cemetery 'B' at Tepe Sialk, are plain cast bronze discs with a short tang, once fitted into a wooden or bone handle. Much more rarely they have a handle in the

shape of a standing naked woman with her arms outstretched above her head and riveted to the base of the disc. Even more unusual are plain discs with a cast loop handle, with animal heads on the terminals, riveted to the back of the disc. This distinctive type of mirror came to Luristan from the north. It is unknown in Elam and Mesopotamia.

# V. VESSELS

THE metal vessels from Luristan illustrate a fresh aspect of the local bronze industry. Although the Luristan smiths were primarily masters of casting, they were no less active, if less skilful and original, in working sheet metal. Hammering and annealing was the only method by which sheet metal could be produced in antiquity, but even so the metal could be worked down from thick sheets cast in open moulds until it was remarkably smooth and thin. Most of the vessels from Luristan were made either by sinking or raising from a single sheet of metal. Handles and spouts of beaten metal were secured to the body of the vessel with rivets, usually split, with domed sheet-metal heads. Certain seams were folded and hammered, sometimes perhaps sealed with an adhesive to make them absolutely watertight. The appearance of cast attachments, with a decided thickening of the body and a tendency to sculptural decoration in the cast parts, is a development of the late ninth or eighth centuries B.C. and may have been inspired by metalwork from north-west Persia or Urartu (in the region of modern Armenia).

Before considering these sheet-metal vessels in detail, attention must be called to a rare *cast-bronze vessel* in the British Museum (Plate XVIII). Its decoration associates it with the workshops producing horse-trappings and finials in the eighth and seventh centuries B.C. Cost of production and the technological expertise required to make them may probably be held to explain the virtual absence of cast vessels from the Luristan repertory, though cast affixes and handles are not uncommon. The stylized lions and moufflon cast in low relief on the surface of this vessel have all the stylistic traits of the finials and the harness-rings on which these animals also regularly appear.

Simple undecorated sheet-metal *bowls* and *beakers* were used in Luristan from at least the middle of the third millennium B.C. Examples have been found in excavations at Bani Surmah, Tepe Giyan, and Tepe Guran which span the period c. 2500–1000 B.C. In form these vessels closely resemble those used at the same time in countries to the west and south-west; indeed, examples have been reported from Luristan bearing the names of Elamite and Mesopotamian rulers. Even in the earlier first millennium B.C. some of the commonest forms of metal bowls and jars from Luristan have very close parallels from excavations at Susa in Elam,

Uruk in Babylonia, and Nimrud in Assyria. There are also a number of metal bowls from the region whose decoration indicates foreign manufacture, normally in workshops under strong Assyrian influence, perhaps in north-west Persia if not in Assyria itself, but including bowls of Syrian or Phoenician manufacture.

One type of vessel is more certainly Persian. The tall, narrow *goblets*, with rather concave sides, were often decorated in Luristan with animal scenes in panels set within floral borders (Plate XVI). Both design and execution are generally rather poor. There is a close affinity between the decoration of these vessels and of some cruder disc-headed pins. Such vessels are provincial derivatives from the magnificent decorated goblets of this form in gold and silver produced by the craftsmen who served the men buried in the cemetery at Marlik, close to the south Caspian shores, late in the second millennium B.C. The Luristan smiths adapted the northern form to their own tastes a few centuries later.

A group of vessels from Luristan commonly known as *situlae* bear no relation to the ceremonial metal buckets with movable curved handles similarly described in archaeological literature. These occur in Luristan under strong Assyrian influence. The Luristan situlae are cylindrical in shape (some straight sided, some with a slight concave curve), taper to a button base, have no handle, and vary from about twelve to seventeen centimetres in height. Many are plain or very simply decorated. There is, however, one richly decorated group. These are all more or less identical in form and in the arrangement of the decoration in a central panel between guilloche and floral borders. A small selection of subjects, notably animals, real and imaginary, scenes of feasting, hunting, and war are chased on the surface with care and skill. A small number of inscribed examples bearing the names of historical personages indicate that the main period of their production fell in the later tenth century B.C., and that their owners were Babylonians. The minor arts of Babylonia at this time are virtually unrepresented in the archaeology of Iraq. The closest parallels both to the style and iconography of these decorated situlae are to be found on a few carved boundary-stones and rare cylinder seals from Babylonia.

A situla of this kind in the British Museum (Plate XVII) is of some particular interest not so much for its design, which is standard, but for a lid said to belong to it. This is decorated not in the style of the situlae, but in the manner typical of Luristan from the ninth century B.C. If the association is accepted, then the lid must have been made in Luristan to fit a vessel made somewhere to the west under strong Babylonian influence.

A few of the sheet-metal vessels from Luristan have a cast-bronze foot riveted to their base. There are also a few cast-bronze *stands* from the

region, normally undecorated, which would have served to hold the situlae and other vessels which could not have stood on their round bases.

It is the *spouted vessels* which best illustrate various aspects of a distinctively Persian tradition among the bronze vessels from Luristan. The form was long popular both in baked clay and metal. The earliest examples from the region, with a short spout drawn out from the lip at an angle of 45° have exact parallels, both in Babylonia and Elam in the later third millennium B.C. (Plate XIX, right). Very similar vessels in baked clay were found at Tepe Sialk, to the east of Luristan, as early as level III, *c.* 3200 B.C.

A different form appears in Luristan, and in cemetery 'B' at Sialk both in baked clay and metal, in the earlier first millennium B.C. As it was used earlier south-west of the Caspian this type of vessel may have been introduced into Luristan from the north. These vessels have a rounded body with low, flat foot and vertical neck, varying in height. A spout, made separately, is attached with large domed rivets (Plate XIX, left). The lower end of the spout is beaten out into a pronounced globular swelling or pouch, generally decorated with chased linear patterns, occasionally transformed into a grotesque face.

A vessel of this type was found on the island of Samos off the Turkish coast in an archaeological context dated *c.* 750–600 B.C., by the excavator. This vessel probably did not reach the west before *c.* 700 B.C. A more elaborate type of spouted vessel, with cast affix in the form of a winged man with hands clasped on his chest, was found during French excavations at Hamadan in 1913. It may be dated to the later seventh century B.C. and marks the end of the vessel's history in the region. As hollow baked-clay figurines both of men and women pouring libations from spouted vessels have come from Marlik and Luristan they may all have served a ritual purpose, rather than a domestic function. The large pouch no doubt regulated the flow of a precious liquid, perhaps the juice of the Haoma plant which played so vital a part in later Zoroastrian ritual.

Contemporary with these elaborate, and often clumsy, vessels were others which seem more practical. These plain bowls have a slight foot, a moulding round the shoulder and a spout usually drawn out from the lip, rather than riveted on. But even these vessels, to judge by a finely decorated example in the British Museum (Plate XX), were used in cult services. The style of the decoration on this vessel associates it with the disc-headed pins and a series of sheet-metal objects which will be the concern of the concluding chapter.

# VI. MISCELLANEOUS SHEET-METAL OBJECTS

VESSELS were but one aspect of sheet-metal production in Luristan. Sheet-metal bracelets and finger-rings have already been discussed, but a variety of belts and belt-fittings, quiver plaques, 'girdle-clasps' and discs of sheet metal commonly reported from the region are of particular interest. As with the vessels and bracelets it is decoration rather than form which distinguishes these objects from others made outside Luristan. When the objects are plain or very simply decorated with crude linear designs, it is rarely possible in the present state of knowledge to distinguish them from the products of workshops elsewhere in western Persia. When they are more elaborately decorated, on the other hand, they are very much more instructive. They reveal cultural affiliations to some extent different from those of the decorated cast bronzes. This is not to say that the two represent distinct traditions of metalworking. They almost certainly do not. There are clear links in style and iconography with the cast bronzes, whilst both appeared together in the Dum Surkh shrine. But in so far as there is greater scope for narrative designs in chasing sheet metal than in preparing wax models for casting, there is greater opportunity for the artisan to reveal, albeit unknowingly, the sources upon which he drew for his designs.

In Assyria, as also no doubt in Persia, *quivers* were made of leather on a wicker or wood framework, the surface sometimes fortified with sheet-metal plaques. On the quivers carved on Assyrian reliefs from Ashurnasirpal II to Ashurbanipal (883–627 B.C.) by far the commonest decoration was of simple geometric or floral designs; such quiver plaques have been found at Uruk in Babylonia and War Kabud in western Luristan. Only on the reliefs of Ashurnasirpal II do quivers bear scenes of goats or priests flanking a tree and various ritual scenes set in registers one above the other. Quiver plaques of this type, decorated in an 'Assyrian' or 'Babylonian' style have been reported from western Luristan. Such objects may have been the inspiration for a small group of quiver plaques decorated in a distinctively Persian style reported sporadically from Luristan since excavations in the Dum Surkh shrine. Although no two scenes on these objects are exactly alike they use the same range of motifs and are executed in the same style as the finest of the disc-headed pins. Whether these scenes do in fact show aspects of pre-Zoroastrian religious practice in Persia is still a matter of lively debate.

39

There are two main groups of decorated *metal-belts* from Luristan. The first are usually of gold or silver, decorated with processions of figures normally carrying offerings. The figures on these belts and a number of other sheet-metal objects, including the spouted vessel (Plate XX) and disc-headed pin (Plate XV*a*) in the British Museum, are characterized by hair swept up at the back, long robes with tasselled girdle and hem, and a facial type distinguished by prominent straight noses, large eyes, thin lips, and straggly beards. Identical human figures appear on carved ivories from Hasanlu and Ziwiyeh, sites to the north of Luristan, in the ninth to eighth centuries B.C. These belts were probably worn by priests.

Formidable as the barrier of the Zagros may seem it never hindered a vigorous trade between Persia and the west. Metals, precious stones, notably lapis lazuli, and horses went to cities in Mesopotamia and beyond; what came in exchange is not always clear, but manufactured goods: fine metalwork, objects of ivory and faience, perhaps textiles, were prominent among them. Assyrian influence is already marked at Marlik in the later second millennium B.C. Finds in level IV at Hasanlu, destroyed *c.* 800 B.C., and at Ziwiyeh, as well as sites yet to be certainly identified in the same general area, indicate the extent to which local craftsmen knew and copied imported objects from Assyria and Syria *c.* 850–650 B.C. Assyrian political and diplomatic activity at this time reinforced the more tenuous links of commerce. The designs on many of the disc-headed pins, quiver plaques, belts, and vessels from Luristan reflect a blending of intrusive Assyrian themes and motifs with local traditions of style and imagery. The exact course of this process has yet to be charted. It seems probable that shrines like that at Dum Surkh were served by craftsmen who worked in copper and bronze, but were much influenced by designs on objects of precious metal, faience, or ivory imported from workshops further to the north in Kurdistan or Azerbaijan as well as direct imports from Babylonia reaching them through western Luristan. It is a process which was likely to have been quite independent of the Iranian migrations.

The second group of decorated belts, this time of bronze or copper, seem to be a more local product and have more certain links with the cast bronzes of Luristan. The figures are more crudely rendered and the designs not so carefully organized. Scenes of hunting and war, perhaps indicating that these belts were worn by soldiers, include motifs found on the finials and pins with openwork cast-bronze heads.

Isolated rectangular plaques of sheet metal, some decorated, may originally have been fitted to fabric or leather belts. A number of lozenge-shaped plaques with a concave underside probably formed a simple piece

of body armour fixed to a belt which kept it in place on the abdomen. Some belts, whether of leather, fabric, or linked chains is not clear, were secured by sheet-metal *clasps*. A strand of wire was curved round to form a long, narrow loop; the ends were turned back and hammered out to form two flat plaques decorated with a variety of chased and repoussé designs, some similar to those used on belts completely of metal.

It is much more difficult to assign an appropriate function to a whole variety of discs, decorated and undecorated, from Luristan. They are generally referred to as *shield-bosses*, and in some cases, particularly when they have a prominent umbo in the centre and holes in the flange, this may be so; but others could equally well be decorative fittings for belts or pieces of body armour according to size. On Assyrian reliefs some soldiers wear a circular plaque on their chests secured by cross-straps. At least one of these plaques is decorated very elaborately in the style of the situlae (Chapter V). A low central boss, pierced in the centre, and a surrounding flange without any suspension holes, may denote a cymbal, though these are apparently commoner in north-west Persia than in Luristan.

# EPILOGUE

## FORGERIES

EVERY student of the bronzes reported from Luristan should be aware that an increasing number are of dubious authenticity, particularly richly decorated pieces. Although the quantity of genuine bronzework, especially the common tools and weapons, is definitely enormous, commercial pressures, both inside Persia and elsewhere, have steadily fostered a market in replicas and forgeries. These are often extremely difficult to distinguish from genuine objects, particularly when so much has been found, but so little from controlled excavations. The British Museum collection is very important in this respect, since it contains a number of objects, particularly finials and horse-bits, which entered the Museum long before the first major phase of clandestine excavation in the nineteen-twenties. Such objects must form the basis for any study of the bronzes from Luristan.

The following main types of forgery are current:

1. Inept reproductions, mainly for the tourist or interior decorators' market, in modern alloys.

2. Ancient sheet-metal vessels decorated with fragments of cannibalized finials or pins soldered or riveted to the sides.

3. Linear designs—including inscriptions—traced or engraved on undecorated ancient objects, usually belts or vessels, but occasionally dagger- and axe-blades. The subjects are sometimes copied from much later objects.

4. Contrivances in which the sound parts of badly damaged ancient objects are conflated to make a single perfect object *or* fragments of diverse ancient objects, often different in date, are used to make a single object of exotic form unknown in antiquity.

5. After-casts from genuine original objects; these are fractionally smaller than the original, if it can be traced, and since they would almost certainly be made in two-piece or multiple moulds, would have seams not to be found on the original ancient object cast by the lost-wax process.

6. Original modern cast-bronze objects imitating, with varying degrees of competence, the style and iconography of ancient artefacts. There is a tendency for these to be bigger and more elaborate than the genuine ancient objects of the same type.

# SELECT BIBLIOGRAPHY

## GENERAL STUDIES OF ART, ARCHAEOLOGY, AND HISTORY IN ANCIENT IRAN

R. GHIRSHMAN, *Iran, from the Earliest Times to the Islamic Conquest*, London, 1954. *Persia, from the Origins to Alexander the Great*, London, 1964.

A. GODARD, *The Art of Iran*, London, 1965.

E. HERZFELD, *Iran in the Ancient East*, London, 1941. (Many of the bronzes from Luristan illustrated in this book are now in the British Museum).

A. U. POPE (ed.), *A Survey of Persian Art from Prehistoric Times to the Present*, London, 1938, volume i (text), iv (plates).

E. PORADA, *Ancient Iran: the Art of Pre-Islamic Times*, London, 1965. (The best and most recent concise survey.)

## BRONZES FROM LURISTAN

So far there is no general study of ancient Persian metalwork in English.

P. R. S. MOOREY, *Catalogue of the Ancient Bronzes in the Ashmolean Museum*, Oxford, 1971. (This comprehensive, and fully illustrated, catalogue of a very representative collection presents in detail the arguments summarized in this booklet.)

There are a number of important works in French and German on various aspects of the ancient bronze industry of Luristan:

P. CALMEYER, *Datierbare Bronzen aus Luristan und Kirmanshah*, Berlin, 1969. (A systematic study of groups among the Luristan bronzes which may be dated on the basis either of the inscriptions some bear or of comparable examples from controlled excavations, often outside Iran.)

J. DESHAYES, *Les Outils de Bronze, de l'Indus au Danube (IV^e au II^e millénaire)*, 2 volumes. Paris, 1960. (A fundamental corpus of bronze tools, and some weapons, with good commentary.)

A. GODARD, *Les Bronzes du Luristan* (Ars Asiatica XVII), Paris, 1931. (The first, and still basic, book on these bronzes.)

J. A. H. POTRATZ, *Die Pferdetrensen des Alten Orient*, Rome, 1966. (This book includes a very full discussion of the horse-bits from Luristan.)

C. F. A. SCHAEFFER, *Stratigraphie comparée et Chronologie de l'Asie occidentale (III^e et II^e millénaires)*, Oxford, 1948. (Chapter viii is a stimulating, if often unorthodox, essay on the chronology of the bronzes from Luristan. Superseded at many points by subsequent work, it remains the best discussion of Luristan's possible Caucasian connections.)

L. VANDEN BERGHE, *Archéologie de l'Iran ancien*, Leiden, 1959. (Reprinted 1966. This valuable reference book contains an extensive bibliography of the 'Luristan Bronzes' up to the date of publication.)

L. VANDEN BERGHE, *Het Archeologisch Onderzoek naar de Bronscultuur van Luristan, Opgravingen in Pusht-i Kuh, I: Kalwali en War Kabud (1965 en 1966)*, Brussels, 1968. (French summary. Report on the excavations of the important Belgium Luristan Expedition in the Ilam region; their work is still proceeding.)

P. CALMEYER, *Reliefbronzen in babylonischem Stil*, Munich, 1973. (A detailed study of the decorated situlae; see Plate XVII here.)

Current archaeological research in Iran is regularly reported in *Iran*, journal of the British Institute of Persian Studies in Teheran.

# SHORT CHECK-LIST OF LURISTAN BRONZES
# IN THE BRITISH MUSEUM

As a catalogue is not appropriate in a booklet of this kind, the following brief list has been drawn up to assist students wishing to know in more detail the range of the British Museum's collection of 'Luristan Bronzes'. Such a list cannot hope to be final as matters of opinion rather than fact too often enter into definitions of what is or is not a 'Luristan Bronze'. The bibliography is not intended to be comprehensive, though it is hoped that all published objects have been traced at least to the primary source.

## ABBREVIATIONS

| | |
|---|---|
| *AfO* | *Archiv für Orientforschung.* |
| *AMI* | *Archäologische Mitteilungen aus Iran.* |
| *BJ* | *Berliner Jahrbuch.* |
| *BMQ* | *British Museum Quarterly.* |
| Deshayes | J. Deshayes, *Les Outils de Bronze, de l'Indus au Danube,* (*IV^e au II^e millénaire*), 2 vols., Paris, 1960. |
| *Iran* | E. Herzfeld, *Iran in the Ancient East,* 1940. |
| *M-H* | R. Maxwell Hyslop in *Iraq*, viii (1946), pp. 1 ff. |
| Potratz | J. A. H. Potratz, *Die Pferdetrensen des Alten Orient,* 1966. |
| *SPA* | A. U. Pope (ed.), *A Survey of Persian Art,* 1938. |

\* Acquired before 1925.

## WEAPONS AND TOOLS (CHAPTER I)

SHAFT-HOLE AXES

| | |
|---|---|
| BM 128617 | *Iran*, pl. xxvii, top, centre; *BMQ*, xi, pl. xxi. 5, p. 60; Deshayes, no. 1405. |
| BM 128683 | *Iraq*, xi (1949), p 107, pl. xxxv. 17*a*; ? *AMI*, i (1929–30), pl. v, left. |
| BM 128684 | *AMI*, i (1929–30), pl. iv, left; Deshayes, no. 1373. |
| BM 128687 | *Iran*, pl. xxvii, centre, left; Deshayes, nos. 1345–6. |
| BM 130676 | *BMQ*, xvii, p. 12, pl. iii; Deshayes, no. 1475.   (Pl. I*a*) |
| BM 122913 | spike-butted axe. |
| BM 122915 | spike-butted axe; zoomorphic terminals to spikes. |
| BM 122931 | *BMQ*, vi, pl. xxix*b*, p. 80; Deshayes, no. 1479. |
| BM 130703 | spike-butted axe. |
| BM 132218 | miniature spike-butted axe with bird on top edge. *BMQ*, xxvi, p. 98. |

### PICK-AXES

BM 128682      *Iran*, pl. XXVII, centre, right; Deshayes, no. 1368.
BM 128685      *Iran*, fig. 244, right, pl. XXVII, centre, 2nd right.
BM 128686      *Iran*, p. 126, fig. 243*a*, pl. XXVII; Deshayes, no. 1380–1.
                    *Iraq*, xi (1949), p. 105, pl. XXXV. 15.

### ADZE

BM 128766      *Iran*, fig. 243, lower right.

### AXE–ADZE

BM 128613      *BMQ*, xi, pl. XXI. 1, p. 60.

### HAMMERS

BM 128614      *Iran*, pl. XXVII, upper left, fig. 248, centre; *BMQ*, xi, pl. XXI. 2, p. 60.
BM 128615      *Iran*, pl. XXVII, upper right; *BMQ*, xi, pl. XXI. 3, p. 60.
BM 128688      *Iran*, fig. 248, top, left.

### CRESCENTIC AXE–HEAD

BM 122191      *BMQ*, v, p. 110, pl. LIV*a*, left.    (Pl. I*b*)

### DAGGERS AND SWORDS

BM 120938      M-H: Type 32.
BM 122932      *BMQ*, vi, pl. XXX*a*; M-H: Type 35*b*.
BM 123058      M-H: Type 41; *BMQ*, vii, p. 27.
BM 123060      *BMQ*, vii, pl. XVIII, pp. 44–5; M-H: Type 35; *AfO* 19, pp. 95 ff. n. 4. p. 55*a*.    (Pl. II*a*).
BM 123061      *BMQ*, vii, pl. XVIII, pp. 44–5; M-H: Type 35*a*: *AfO* 19, pp. 95 ff. n. 3; Pope, *SPA* (1938), pl. 55*c*.    (Pl. II*b*).
BM 123298      M-H: Type 38*a*.
BM 123315      M-H: Type 39.
BM 128618      *Iran*, pl. XXVIII, 3rd from right; *BMQ*, xi, pl. XXI. 6, p. 61; M-H: Type 37.
BM 128690      M-H: Type 12*e*.
BM 128761      *Iran*, pl. XXVIII, 2nd from right; M-H: Type 38.
BM 128762      M-H: Type 40*a*.
BM 128763      *Iran*, pl. XXVIII, right.

### IRON SWORD

BM 123304      (Pl. II*c*).

### HILTS ONLY

BM 128767      flanged bronze hilt.
BM 129378      *BMQ*, xii, pl. XII, pp. 36–7: silver.    (Pl. III)

### BRONZE SWORD BLADE

BM 128619      *BMQ*, xi, pl. XXI. 7.

### BIDENT

BM 128742      *Iran*, fig. 260, bottom, centre.

### ARROWHEAD

BM 122920      *BMQ*, vi, pl. XXIX*d*, p. 80.

### SPEARBUTTS(?)

BM 128768–9.

CUDGEL HEADS (?)

BM 128716    *AMI*, 1 (1929–30), pl. v, right.
L 1156       Victoria and Albert Museum Loan.

MACEHEADS

BM 128616    *BMQ*, xi, pl. xxi. 4; *Iran*, pl. xxvi, top, centre.
BM 128691    *Iran*, pl. xxvi, top right.
BM 128719

WHETSTONE SOCKETS

BM 119436    cervid with head turned back.
BM 122190    in form of an ibex with an animal on its back; *BMQ*, v, pl. Liva.
             (Pl. IV*b*)
BM 122916    in form of a moufflon; *BMQ*, vi, pl. xxx*d*.   (Pl. IV*a*)
BM 128792    in form of a lion's head; *Iran*, fig. 253.
BM 128793    in form of a boar's head.
BM 129395    in shape of a boar; *BMQ*, xiii, p. 16, pl. ix*c*.   (Pl. IV*c*)
BM 132058    in form of a 'master-of-animals' in exotic style of Luristan
             flanked by four stylized lions.

## HORSE-HARNESS (CHAPTER II)

HORSE-BITS

Group 1
  BM 130681    *BMQ*, xvii, p. 12, pl. iii; Potratz, pl. xlviii. 112.   (Pl. VI*a*)
Group 2
  BM 128731    Potratz, pl. L. 118.   (Pl. V*a*)
Group 3
  BM 122914    *BMQ*, vi, pl. xxx*e*, p. 79.
  BM 128770    Potratz, pl. lv. 129.
  BM 130675    *BMQ*, xvii, pl. iii, p. 12.   (Pl. V*b*)
Group 4 (no examples).

Group 5

MOUFFLON CHEEK-PIECES

BM 122930    *BMQ*, vi, pl. xxix*e*, p. 79.
BM 123273    Potratz, fig. 64*a*.

HORSE CHEEK-PIECES

BM 122928    *BMQ*, vi, p. 79, pl. xxix*c*.
BM 134927    horse-and-rider cheek-piece.   (Pl. VI*b*)

MYTHICAL BEASTS AS CHEEK-PIECES

*BM 123272   Potratz, p. 157, no. 1 (lower), fig. 66.   (Pl. VII*a*)
*BM 123276   Potratz, p. 150, no. 2, fig. 63*g*.   (Pl. VII*b*)
BM 130677    *BMQ*, xv, pp. 58–9, pl. xxv*b*.
BM 134746    Bit with cheek-pieces in the form of winged human-faced bulls,
             *BMQ*, xxxii, p. 57.

HARNESS-RINGS

1. Spoked wheels
  BM 122924–5    plain.
  BM 122926–7    *BMQ*, vi, pl. xxix*a*, p. 80.   (Pl. VIII*a*)

47

HARNESS-RINGS (*cont.*):

  2. Open rings with moufflon head and flanking lions
    BM 122917      *BMQ*, vi, pl. xxx*b*, p. 80.
    BM 123542      *BMQ*, ix, pl. xxix*b*, p. 94.  (Pl. VIII*b*)

  3. Figure-of-eight with zoomorphic decoration
    BM 122918      *BMQ*, vi, p. 80.

  4. 'Bow-rings' (probably buckles or harness-trappings)
    BM 132308
    BM 123301

  5. Sheet-metal 'jingles' for horse-harness
    BM 128726–7

  6. Decoration for a horse-collar
    BM 128606      *BMQ*, xi, pl. xx. 2, p. 59.

  7. Horse-bell
    BM 128721

  8. Chariot rein-ring (probably Elamite of the later third millennium B.C. though attributed to Luristan)
    BM 122700      *BMQ*, vi, pl. xv*a*, pp. 32–3; *SPA*, iv, pl. 26.

## FINIALS AND DECORATED TUBES (CHAPTER III)

FINIALS

  1. Rampant ibexes
    BM 122911      (Pl. XI*b*)

  2. Rampant ibex with lionhead and neck on each shoulder
    BM 123541      *BMQ*, ix, pl. xxix*a*, p. 94.  (Pl. IX)

  3. Rampant stylized lions
    *BM 115516
    BM 122192      *BMQ*, v, pl. LIV*a*, bottom.
    BM 122912
    BM 122929      *BMQ*, vi, pl. xxx*c*.  (Pl. XI*a*)

  4. 'Master-of-Animals'
    *BM 87216
    *BM 108815
    *BM 108816      (Pl. X*a*)
    *BM 108817
    *BM 115514      (Pl. X*b*)
    *BM 115515

ANTHROPOMORPHIC TUBES

  BM 123300      (Pl. XII*c*)
  BM 130685      *BMQ*, xvii, pl. III, p. 13.  (Pl. XII*b*)
  BM 132346      *BMQ*, xxvi, p. 98, pl. XLVIII*d*.  (Pl. XII*a*)

BOTTLE-SHAPED SUPPORT FOR FINIAL

  BM 123057

## PINS, PERSONAL ORNAMENTS, ETC. (CHAPTER IV)

GROUP IA: pin-heads cast as plain, geometric shapes

  BM 128705
  BM 128706      *Iran*, fig. 272, 3rd from right.

| BM 128707 | *Iran*, fig. 272, 2nd from right. |
| BM 128708 | *Iran*, fig. 272, 2nd from left. |
| BM 128709 | *Iran*, fig. 272, 3rd from left. |

GROUP IB: FLORAL HEADS

No examples.

GROUP IC: ZOOMORPHIC AND ANTHROPOMORPHIC HEADS

| BM 128472–3 | winged 'wild asses' couchant; originally on iron pins. |
| BM 128607 | *BMQ*, xi, pl. xx. 4, p. 58—winged 'dragon'; *Iran*, fig. 275. (Pl. XIV*a*) |
| BM 128608 | *BMQ*, xi, pl. xx. 3, pp. 58–9; *Iran*, fig. 275: human figure and crescent. |
| BM 128783 | *Iran*, fig. 275, top right: lion-mask originally on iron pin. (Pl. XIII*c*) |
| BM 128786 | stylized lion couchant. |
| BM 128787 | winged gazelle(?) |
| BM 128788 | moufflon(?) |
| BM 128710 | moufflon. |
| BM 128789 | duck with head turned back along spine. |
| BM 130680 | *BMQ*, xvii, pl. III, p. 12: moufflon couchant on a lion-head. |
| BM 130683 | stylized lion couchant. |
| BM 130684 | *BMQ*, xvii, pl. III, p. 12: human head. |
| BM 132057 | winged 'dragon' head. |
| BM 132927 | *BMQ*, xxvi, pl. XLVIII*e*, p. 98: 'master-of-animals'. (Pl. XIII*a*) |
| BM 132928 | *BMQ*, xxvi, pl. XLVIII*b*, p. 98: stylized lion couchant. |

GROUP II: OPEN-CAST HEADS

| BM 123299 | (Pl. XIII*b*) |
| BM 128780 | (Pl. XIV*b*) |
| BM 128782 | |

GROUP III: DISC-HEADED PINS

| BM 132025 | (Pl. XV*b*) |
| BM 132900 | *BMQ*, xxvi, pl. XLVIII*c*, p. 98.   (Pl. XV*a*) |

BRACELETS: CAST BRONZE

| BM 130678 | *BMQ*, xvii, pl. III. sitting-duck terminals |
| BM 122922 | sitting-duck terminals. |
| BM 122921 | sleeping-duck terminals. |
| BM 128795 | moufflon (?) terminals. |
| BM 122923 | moufflon (?) terminals. |
| BM 123543 | *BMQ*, ix, p. 95. |
| BM 128772 | heavy casting in two pieces; upper surface decorated. |

EAR-RINGS

BM 128797–8

TORC

| BM 128771 | twisted hoop. |

TOGGLE

BM 123302

49

| | |
|---|---|
| BM 128740–1 | double-spiral: *BMQ*, xi, pl. xx. 5; *Iran*, pl. xxx. Silver. |
| BM 122193–98 | moufflon. |
| BM 128778 | moufflon. |
| BM 122199 | horse. |
| BM 128775 | horse: *Iran*, pl. xxxi, lower right. |
| *BM 108814 | horse. |
| BM 1929–1–16, 18 | horse. |
| BM 128777 | bull—*Iran*, pl. xxxi, top left. |
| BM 128744 | bull—*Iran*, pl. xxxi, bottom, left. |
| BM 128474 | bull's head. |
| BM 128773–4 | a male and a female figurine with suspension loops. |

## VESSELS (CHAPTER V)

PLAIN VESSELS

BM 128760; 128720; 123055; 131445; 132216

SPOUTED VESSELS: EARLY TYPE

| | |
|---|---|
| BM 128600 | *Iran*, pl. xxv, lower right; *BMQ*, xi, ᶠp. 61, pl. xxiie; *AMI*, I, 1929–30, pl. vi (Gilweran). (Pl. XIX right) |
| BM 128804 | *Iran*, fig. 226; *AMI*, i, 1929–30, pl. vii (Gilweran). |

LATER TYPE

| | |
|---|---|
| BM 123062 | |
| BM 128601 | *BMQ*, xi, pl. xxiid; *Iran*, pl. xxv, lower, centre. (Pl. XIX left) |
| BM 128603 | *BMQ*, xi, pl. xxiib; *Iran*, pl. xxv, top, fig. 216, lower, right. |
| BM 128756 | *Iran*, fig. 216, left. |
| BM 128757 | |
| BM 132930 | *BMQ*, xxvi, pl. xlviiia, p. 98 (Decorated). (Pl. XX) |

CAST-BRONZE VESSEL

| | |
|---|---|
| BM 130679 | *SPA*, iv, pl. 67B; *BMQ*, xv, p. 59, pl. xxvc (Pl. XVIII). Cf. BM 128604: *Iran*, pl. xxv, lower left; *BMQ*, xi, pl. xxiic (Bujnurd). |

DECORATED GOBLET

| | |
|---|---|
| BM 134685 | animal friezes. (Pl. XVI) |

DECORATED SITULAE AND RELATED BOWL

| | |
|---|---|
| BM 130905 | Calmeyer, *BJ*, 5 (1965), p. 30—G. 1. (Animal frieze). (Pl. XVII) |
| BM 134735 | seated human figures. |
| BM 123325 | Calmeyer, *BJ*, 5 (1965), p. 45, O. 6, pl. 6 (bowl). |

FRAGMENT OF A DECORATED VESSEL (*c.* 2000 B.C.)

| | |
|---|---|
| BM 128620 | *BMQ*, xi, p. 60, fig. 1; *Iran*, fig. 229, pl. xxi; Calmeyer, *BJ*, 6 (1966), p. 95, fig. 2b; *AMI*, 8 (1937), pp. 53–5. |

DECORATED BOWL (IIND ISIN DYNASTY)

| | |
|---|---|
| BM 129062 | *BMQ*, vii, pl. xviii, top, p. 45. |

## SHEET-METAL OBJECTS (CHAPTER VI)

BELT FRAGMENTS

| | |
|---|---|
| BM 128724 | *Iran*, fig. 263, lower. |

GIRDLE–CLASP

    BM 128725          geometric decoration.

QUIVER FRAGMENT (?)

    BM 122919          decorated with a lion-mask.

FUNCTION UNCERTAIN

    BM 128728–9     *Iran*, fig. 255, right.

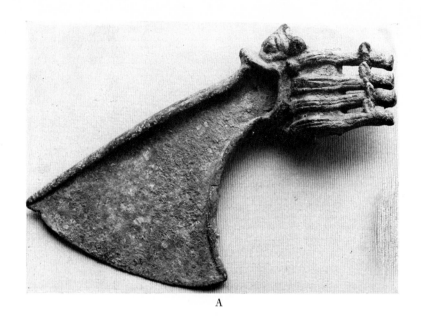

A

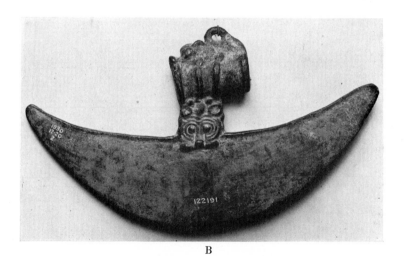

B

Plate I A Bronze spike-butted axe-head (BM 130676)
B Bronze crescentic axe-head (BM 122191); p. 23

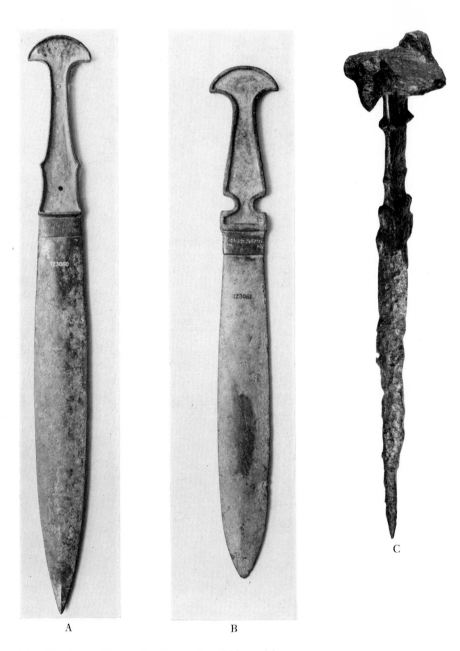

Plate II A Bronze dirk inscribed for an officer (BM 123060)
      B Bronze dirk inscribed for Marduk-nadin-ahhe, King of Babylonia, *c.* 1098–1081 B.C. (BM 123061)
      C Iron sword (BM 123304); pp. 20, 24

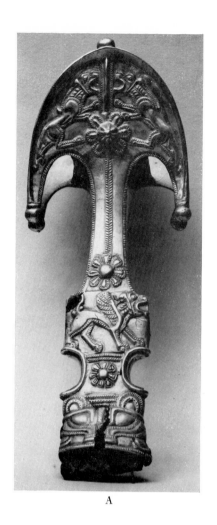

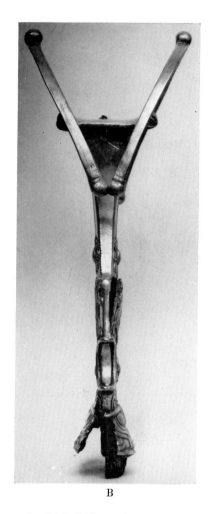

A

B

Plate III (A and B) Silver sword hilt, originally on an iron blade (BM 129378); p. 24

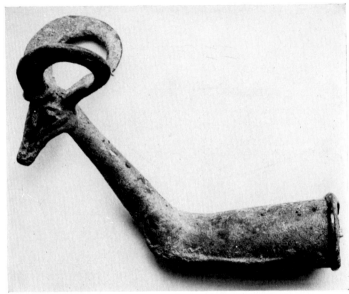

A

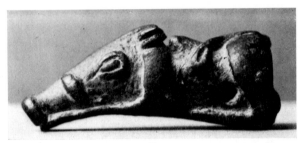

B

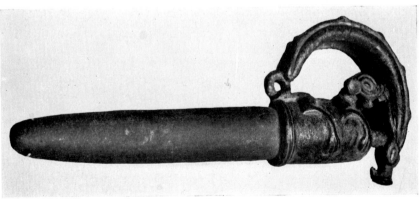

C

Plate IV A Bronze whetstone handle; moufflon (BM 122916)
B Bronze whetstone handle; boar (BM 129395)
C Whetstone with bronze handle; caprid with lion on its back (BM 122190); p. 24

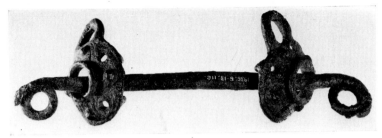

A

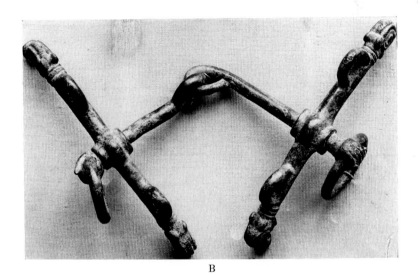

B

Plate V A Bronze horse-bit with circular cheek-pieces (BM 128731); p. 25
B Bronze horse-bit with bar cheek-pieces ending in animal heads (BM 130675);
p. 26

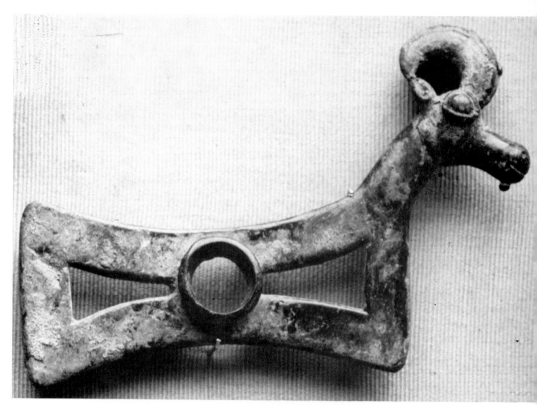

A

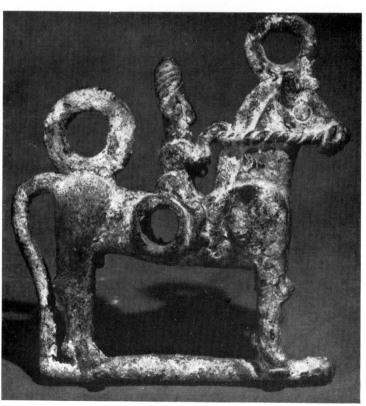

B

Plate VI A Bronze cheek-piece for a horse-bit (BM 130681)
B Bronze cheek-piece for a horse-bit; three-dimensional modelling (BM 134927); pp. 26–7

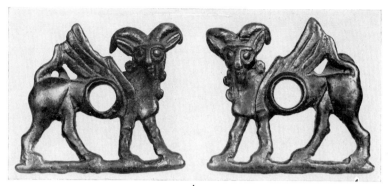

A

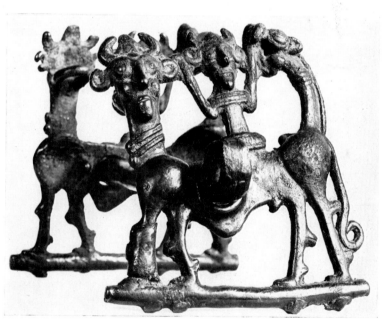

B

Plate VII A Pair of bronze cheek-pieces for a horse-bit (BM 123272)
B Bronze horse-bit (BM 123276); pp. 26–7

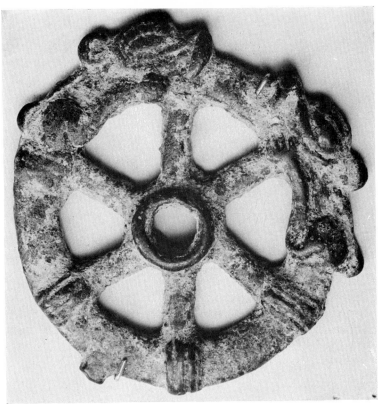

A

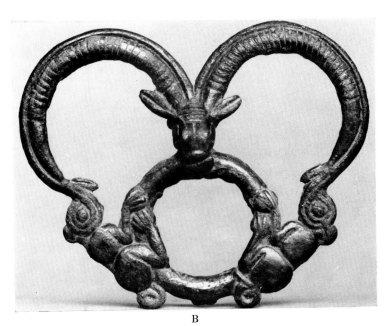

B

Plate VIII A Bronze harness-ring (BM 122926)
B Bronze harness-ring (BM 123542); p. 27

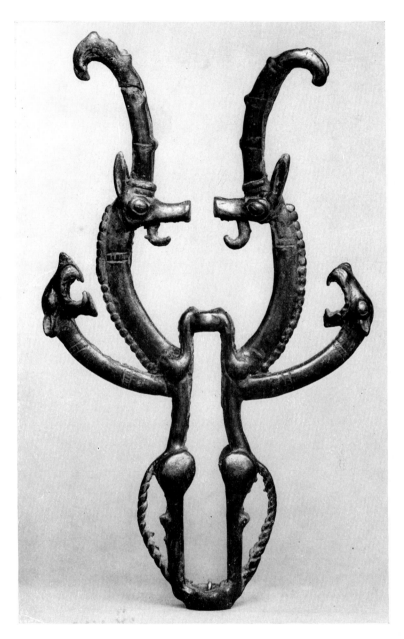

Plate IX Bronze finial; caprid and lion (BM 123541); p. 30

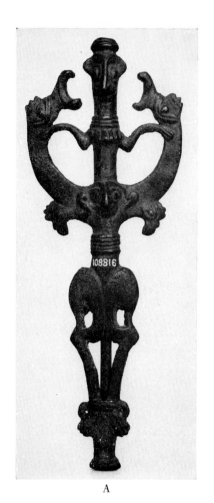

A

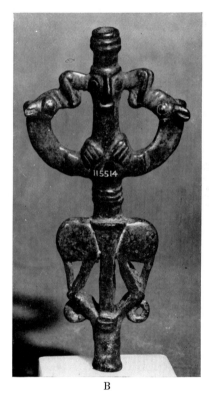

B

Plate X A Bronze 'master-of-animals' finials (BM 108816)
B Bronze 'master-of-animals' finials (BM 115514); pp. 29-30

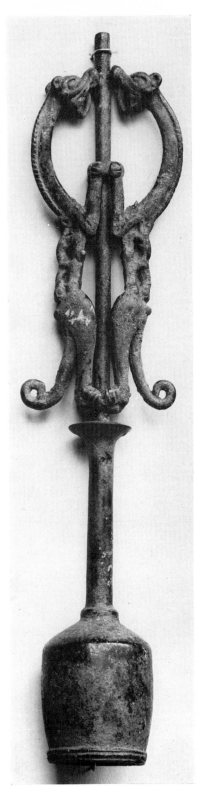

A

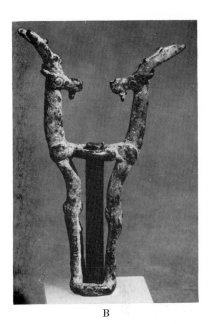

B

Plate XI A Bronze lion finial on mount (BM 122929)
B Bronze caprid finial (BM 122911); pp. 29-30

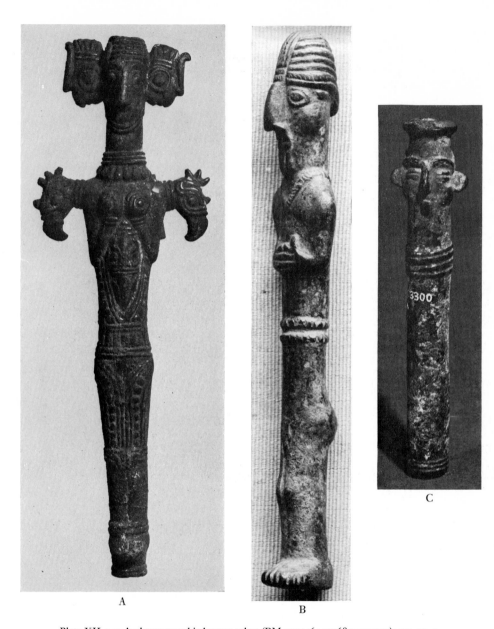

Plate XII A–C  Anthropomorphic bronze tubes (BM 132346; 130685; 123300); pp. 30–1

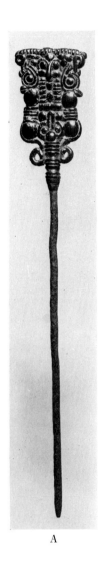

A

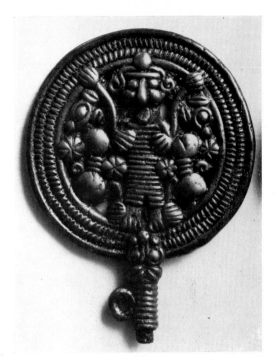

B

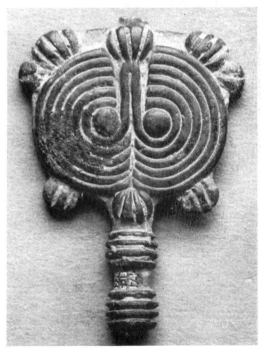

C

Plate XIII A–B Base silver (?) 'master-of-animals' pin-heads (BM 132927; 123299)
C Bronze stylized lion pin-head (BM 128783); pp. 32–3

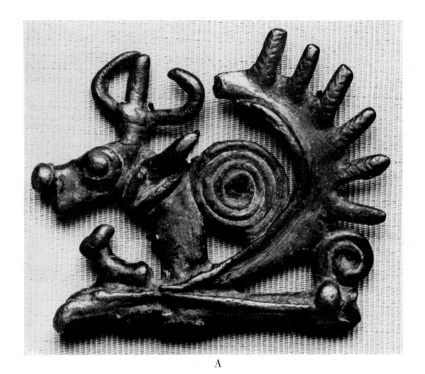

A

B

Plate XIV A–B Bronze pin-heads, originally on iron-shanks (BM 128607; 128780); pp. 32–3

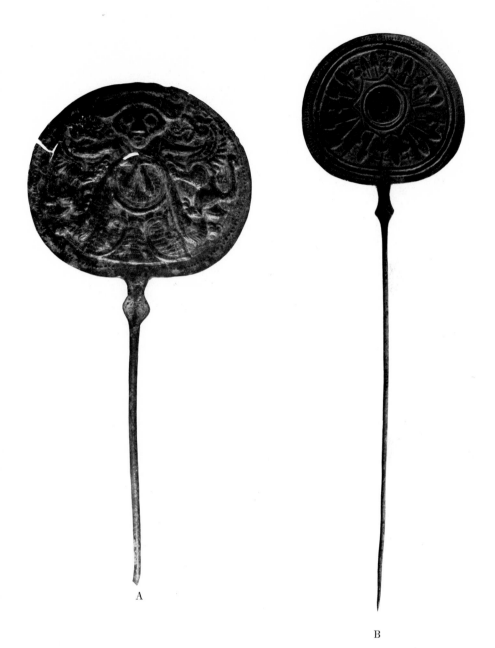

A

B

Plate XV A–B Bronze disc-headed pins (BM 132900; 132025); p. 33

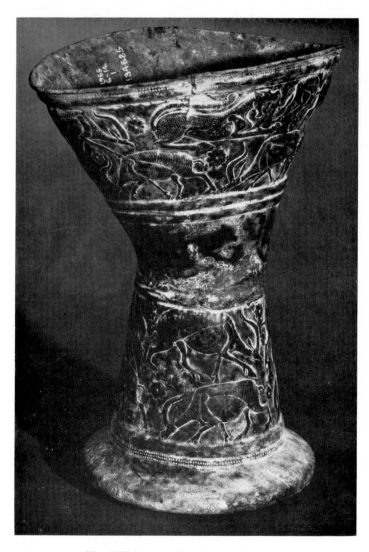

Plate XVI Bronze goblet (BM 134685); p. 37

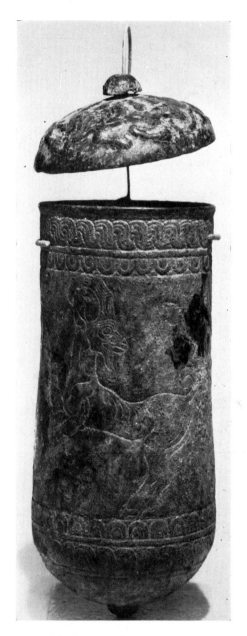

Plate XVII Bronze *situla;* the lid may not belong
(BM 130905); p. 37

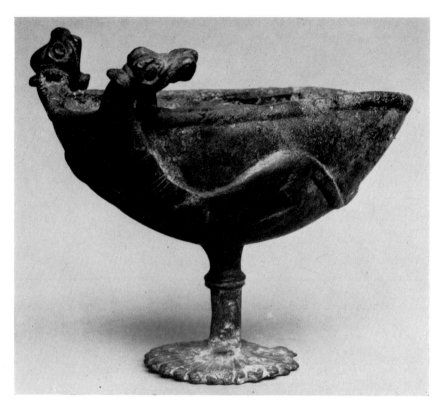

Plate XVIII Cast bronze pedestal bowl (BM 130679); p. 36

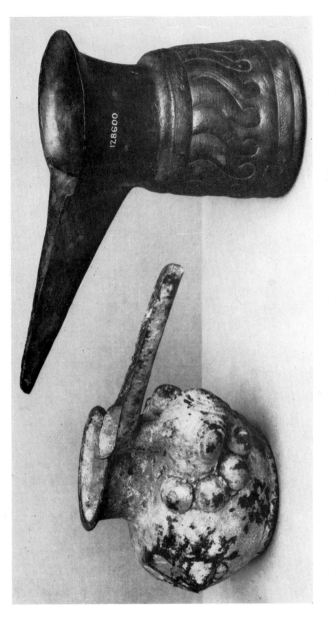

Plate XIX Bronze spouted vessels; *right*: mid-3rd millennium B.C. (BM 128600); *left*: early 1st millennium B.C. (BM 128601); p. 38

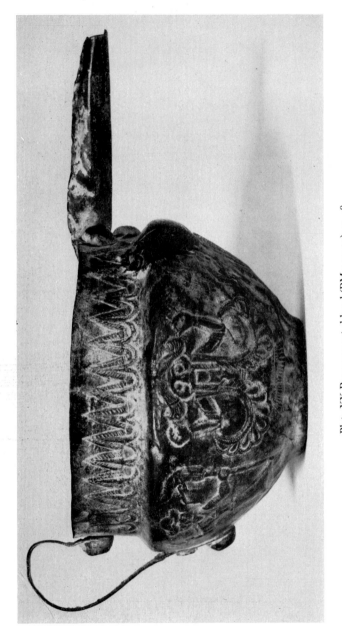

Plate XX Bronze spouted bowl (BM 132930); p. 38